The Drawing Center
November 15, 2013 – January 12, 2014
Drawing Room

Dickinson/Walser
Pencil Sketches

Curated by
Claire Gilman

DRAWING PAPERS 109

Foreword *by* Claire Gilman
Essay *by* Josiah McElheny

PL. 1
Robert Walser in Berlin, c. 1907

PL. 2
Emily Dickinson, c. 1847

PL. 3
Robert Walser, *Microscript 131* (recto), April–May 1926

PL. 3B
Robert Walser, *Microscript 131* (verso), April–May 1926

Without a smile —
Without a Throe
×A Summer's soft
assemblies go
to their entrancing
end
Unknown - for all
the times we met -
Estranged, however
intimate -
What a dissembling
Friend -
+ Do - our -
 nature's soft

PL. 4
Emily Dickinson, *Without a smile – | Without a Throe* (recto), c. 1874

PL. 5
Emily Dickinson, *As there are | Apartments in our* (recto), c. 1880

PL. 6
Emily Dickinson, *Glass was | the Street – / It came his | turn to beg –* (recto), c. 1880

PL. 6B
Emily Dickinson, *Glass was | the Street – / It came his | turn to beg –* (verso), c. 1880

PL. 7
Robert Walser, *Microscript 107* (recto), September–November 1928

PL. 8
Robert Walser, *Microscript 434* (recto), January–March 1928

PL. 9
Emily Dickinson, *Alone and in a Circumstance* (recto), c. 1870

[illegible handwritten letter with affixed postage stamp and clippings reading "GEORGE SAND," and "Mauprat / of bandits"]

He is an ardent Jockey
for so old a man and
his piercing cries of go
caddie when they can hin
find - rend the neighborhood -

not her own. She prayed, ofttimes, | belonged to her master, but lacked
that they might die, yet lived to see | their immunity from his passions and
them toil and suffer. She might long | are in school. What is the outlook for
for the sweetness and privacy of a | age, only seventy thousand of whom
home, but hardly found a kennel. | are girls under twenty-one years of
Like the hound and the horse, she | Seven hundred and fifty-two thousand
 | their children a letter of the language.
 | ability themselves to read, or to teach
ply. The mothers of the race, with | but rare exceptions, are without the
which only their white sisters can sup-

PL. 10
Emily Dickinson, *Such are the inlets of | the mind – / He is an Ardent Jockey* (verso), c. 1877

Of our deepest delights
there is a solemn shyness

the appetite
for silence
is seldom
acquired
Taste

PL. 11
Emily Dickinson, *Of our deepest delights* (recto), after 1873

Foreword

Claire Gilman

This exhibition is the fruit of several happy accidents and the combined efforts of a number of extraordinary individuals, primary among them the subjects of the exhibition themselves: the Swiss writer Robert Walser (1878-1956) and the American poet Emily Dickinson (1830–1886). Although Walser, born shortly before Dickinson's death, was most likely unaware of the latter's work, the two writers share some striking characteristics: both were intensely private and lived their later lives in virtual seclusion: Dickinson in her family home in Amherst, Massachusetts, and Walser in the Waldau mental home near Bern, Switzerland. Both developed idiosyncratic writing methods that resulted in work of astonishing visual complexity that remains largely unknown to the general public today. Walser wrote in tiny, inscrutable script (which he termed his "pencil method") on narrow strips of paper, receipts, and business cards using an antiquated German alphabet that was long considered indecipherable. Only recently have these scraps been shown to consist of early drafts of the author's published texts. Similarly, Dickinson fitted her multifarious poetic fragments to carefully torn pieces of envelope, newspaper, and stationery. As with Walser, this aspect of Dickinson's writing is largely unfamiliar to her readers who, perusing a copy of Thomas H. Johnson's *The Complete Poems of Dickinson*, would never know what her works actually look like, and indeed how important their *look* is to their content.

Dickinson/Walser: Pencil Sketches addresses this situation by assembling a selection of these extraordinary objects for the viewer's contemplation. What is the status of these works? Are they texts? Not exclusively. Drawings? Perhaps. I approached the artist Josiah McElheny to author the catalogue essay both because of his longstanding interest in the interplay between literature and the visual arts, and because I deliberately sought someone outside the realm of Dickinson/Walser scholarship who would greet the work with unbiased and attentive eyes. Josiah has more than risen to the challenge with a wonderful essay in which he approaches these difficult objects as if encountering a new visual form. By preserving the moment of thought's formation and requiring the reader to work to assemble a meaning, these texts become, in Josiah's estimation, closer to sketches or musical scores than to finished products.

I am thrilled to be able to present these hybrid works at The Drawing Center. My aim in doing so is not to claim them definitively as drawings so much as to put them in dialogue with that tradition and to allow our audience to make its own assessment. With their extreme handwriting carefully fitted to the support at hand, their stray marks and linguistic overlays, and their deliberate correspondences between text and incidental image, these objects are best described as "visual works by two writers," with all the uncertainty that that phrase implies.

This exhibition would not have been possible without a series of chance encounters as well as important contributions from several individuals. I had been aware of Walser's writing for a few years and indeed had been considering including him in the exhibition *Drawing Time Reading Time*, which The Drawing Center has organized simultaneously with *Dickinson/Walser*. However, being a writer, Walser did not seem a precise fit for that exhibition's focus on visual artists exploring language. It was not until the artist Amy Sillman informed me that she had seen some amazing facsimiles of Dickinson's fragments compiled by the artist and poet Jen Bervin that the idea for a separate show focused on these two writers formed in my mind. A visit to Jen's studio led to conversations with Michael Kelly at the Dickinson archive at Amherst, and with Reto Sorg of the Robert Walser-Zentrum in Bern, and soon the show was underway. I am deeply indebted to the work of Jen and Marta Werner who together published a limited edition facsimile of Dickinson's envelope poems with Granary Books, as well as to the renowned poet and longtime Dickinson enthusiast Susan Howe. Without these individuals' pioneering scholarship this exhibition would not have been possible.

I am equally indebted to Christine Burgin who, together with New Directions publishing house, brought Walser's microscripts to the English-speaking public in a groundbreaking book of texts published in 2010. The microscripts in that book were masterfully translated and annotated by Susan Bernofsky, whose translations and notes constitute the major part of the extended labels in *Dickinson/Walser*. In a happy coincidence, Christine met Jen Bervin at about the same time I did, and she has since paired with New Directions to produce

a hard-cover edition of Bervin and Werner's limited-edition Granary book. Christine's generosity in sharing her knowledge and contacts with me was unbounded, and her work with New Directions leaves future Dickinson and Walser scholars deeply in her debt.

In addition to the above-mentioned individuals, several people must be thanked for assisting with the logistics of this exhibition and its accompanying public programs. I am extremely grateful to Gelgia Caviezel at the Robert Walser-Zentrum; Magnus Wieland of the Schweizerisches Literaturarchiv at the National Library in Bern; and Barbara Epler, President of New Directions. A special additional thanks to Michael Kelly, Head of Archives and Special Collections at the Frost Library, Amherst College, for his unfailing patience and good humor and his willingness to answer each and every one of our many questions.

The Drawing Center's staff provided invaluable assistance in realizing this exhibition. Special thanks to Brett Littman, Executive Director; our wonderful interns Elizabeth Gambal and Chelsea Pierce; and especially to Nova Benway, Curatorial Assistant, who met the numerous challenges of this show with an admirable mix of enthusiasm, calm and efficiency. Thanks also to Molly Gross, Communications Director; Anna Martin, Registrar; Dan Gillespie, Operations Manager; Nicole Goldberg, Deputy Director, External Affairs; Jonathan T.D. Neil, Executive Editor; Joanna Ahlberg, Managing Editor; and Peter J. Ahlberg/AHL&CO, Designer.

Finally, I am incredibly appreciative of the steadfast support of The Drawing Center's Board of Trustees and the exhibition funders who have supported this exhibition and its accompanying catalogue, including the Swiss Arts Council Pro Helvetia, Consulate General of Switzerland in New York, and New York Council for the Humanities.

If it had no pencil,
Would it try mine —
Worn — now — and dull — sweet,
Writing much to thee.
If it had no word,
Would it make the Daisy,
Most as big as I was,
When it plucked me?
 Emily.

PL. 12
Emily Dickinson, *If it had no pencil* (recto), c. 1861

Upper pin 695.

Lower pin

PL. 13
Emily Dickinson, *With the sincere spite of a Woman* (recto), c. 1880

PL. 14
Emily Dickinson, *Excuse | Emily and | her Atoms / A Mir | acle for all* (recto), c. 1882

PL. 14B
Emily Dickinson, *Excuse | Emily and | her Atoms / A Mir | acle for all* (verso), c. 1882

Misses
Michard Vario D
Amherst
Mass

PL. 15
Robert Walser, *Microscript 419* (verso), presumably winter 1927–1928

PL. 16
Robert Walser, *Microscript 350* (recto), October–December 1928

PL. 17
Robert Walser, *Microscript 340* (recto), presumably August–September 1925

PL. 18
Emily Dickinson, *The way | Hope builds his | House* (recto), c. 1879

PL. 19
Emily Dickinson, *In vain | to punish | honey* (recto), c. 1873

PL. 20
Robert Walser, *Microscript 215* (recto), October-November 1928

PL. 21
Robert Walser, *Microscript 23* (recto), presumably summer 1927

M U

O Meliboee, deus nobis
Namque erit ille mihi se

Absconde te in otio; sed et ipsum otium absco

Hodiernus dies solidus est. Nemo ex illo quice
nemque divisus est.

O Meliböus, ein Gott schuf u
Wahrlich, dieser wird stets N

Verbirg dich in deiner Muße; aber auch deine

Der heutige Tag war ganz mein. Niemand h
Lektüre teilten sich ganz in ihn.

1

SONNTAG / MAR

16	**17**	**18**
MONTAG	DIENSTAG	MITTWOCH
A	U	G

PL. 21B
Robert Walser, *Microscript 23* (verso), presumably summer 1927

PL. 22
Emily Dickinson, *Necessitates | Celerity* (recto), c. 1880

PL. 22B
Emily Dickinson, *Necessitates | Celerity* (verso), c. 1880

PL. 23
Emily Dickinson, *Two things | I have lost | with Child | hood* – (recto), c. 1870-1886

PL. 23B
Emily Dickinson, *Two things | I have lost | with Child | hood –* (verso), c. 1870-1886

PL. 24
Emily Dickinson, *Summer laid | her simple Hat* (recto), c. 1876

246

If wrecked
opon the
+ ~~Wharf~~ Bay-Bay of
thought
How is it
with the sea?
the only
vessel that
is shunned -
Is safe -
Simplicity -
+ /Cabet Dock

PL. 25
Emily Dickinson, *If wrecked | opon the | Bay of | thought* (recto), c. 1879

If wrecked opon
the Shoal of thought
How is it with the
Sea?
The only Vessel
that is shunned
Is safe – Simplicity –

PL. 26
Emily Dickinson, If wrecked opon | the Shoal of thought (recto), c. 1879

PL. 27
Robert Walser, *Microscript 327* (recto), presumably spring 1928

Visual forms for words: Overlaps of art and literature in Emily Dickinson and Robert Walser[1]

Josiah McElheny

[1] In memory of Donald Young, the visionary art gallery owner who introduced me to, among many other things, a new idea of how literature and art can interact.

Handwritten letters and manuscripts are often considered historical or nostalgic artifacts. A set of objects left behind by Emily Dickinson and Robert Walser may be something closer to art, or drawing. They each wrote drafts in pencil on salvaged paper; in both cases the connections between their language and its physical manifestation are complex and intertwined, leaving us with language that must be *seen*, not only read. The two reclusive authors wrote in dialogue with the ground on which their thoughts are marked, on the paper fragments, scraps, and cards that were sometimes purposefully cut or unfolded before writing on them. The importance of these archival materials does not come from a nostalgia for handwriting: in the case of Dickinson, these things constitute a "concrete" language, formed by the landscape or shape on which she was writing, and with Walser, a set of intense—if minute—abstractions, constructed out of words about the ordinary. Ephemeral works on paper that are gorgeous and mysterious, they are hybrid forms that speak about the situational specificity of language and the tension between word as representation and word as specific-object, and between words as definite-sequences and words becoming abstraction; they also contain drafts of texts that are fantastic in any format.

Emily Dickinson's early compositions derive from transcriptions of her handwritten manuscripts on rectangular sheets of paper, but, especially in her later years, she also carefully saved poems—or parts of poems—that were inscribed on unusual, irregularly shaped paper: often these were complex origami-like forms made out of unfolded envelopes or more simply their triangular flaps—the "seals of others" she writes—ripped along the top. Among the most dramatic examples are the tickertape-like strip, *The Lassitudes | of Contemplation*, or the almost representational, "house"-shaped *'Twas later when | the summer went* [PLS. 28 / 29, 29B]. In a funny way, we might be reminded of a shopping list jotted down on the envelope of our electric bill, or more seriously, of myriad later, radical conjoinings of language and object authored by a variety of artists, from the Fluxus group to John Cage to Dieter Roth.

In contrast with Dickinson's dynamic shapes, Robert Walser spent the final years of his writing career scribing on salvaged rectangular cards, receipts, and calendar pages, many of which display

PL. 28
Emily Dickinson, *The Lassitudes | of Contemplation* (recto), c. 1882

make him out great / console / in / what
Trim / the / / action / metre going
refresh / owns / issue /

'Twas later when
the summer went
than when the
Cricket came -
+And set we knew
that gentle Clock
Meant nought but
going Home -
'Twas sooner when
the Cricket went
than when the
Winter came
Yet that pa-
thetic Pendulum
keeps
Esoteric
time

PL. 29
Emily Dickinson, *'Twas later when | the summer went* (recto), c. 1873

PL. 29B
Emily Dickinson, *'Twas later when | the summer went* (verso), c. 1873

"found" printed imagery, visually augmented by the graphic aspects of his minute pencil writing, a script unique to him, his "microscript." Sometimes the shape of his blocks of text echo a form already on the card, sometimes there are holes in the text blocks, sometimes he switches direction. Looking at the materials he repurposed, one remembers the boxes of tickets and receipts obsessively saved by Andy Warhol. And one thinks of the many parallels to the opaque visual writing or the abstractions generated from letter-forms and linguistic notational systems by artists from Kurt Schwitters to Hanne Darboven to Cy Twombly.

The two groups of text-objects have parallel and mirrored histories: Dickinson's jotted scraps of handwriting-language and Walser's scribbled blocks of letter-marks were unknown during their lifetimes and only discovered (and luckily saved) by the executors of their estates. Much has now been written about the complexity of what followed those discoveries. Dickinson's poems eventually became part of her recognized oeuvre, but not in their original form; rather, they were transcribed and edited without reference to their original "location," as it were—one could say that they were translated by the editors into new texts. Walser's microscripts were long considered almost as opaque as cuneiform once was, and they were deciphered only recently. We have since learned that they contain first drafts of both published and unpublished material. Only recently, through loving, devoted scholarship and art, can we view and absorb the originality of these text-objects and more fully experience their fusion of the visual and linguistic.[2]

Dickinson's "final" manuscripts are drawn in a careful, inked script. Sometimes her pen letterforms seem to echo the content, for example

[2] Extensive information and insight about Dickinson can be found in *The Gorgeous Nothings* (2013), a project by scholar Marta Werner and artist Jen Bervin, in collaboration with publishers Christine Burgin and New Directions and with an introduction by Susan Howe. New translations of Walser are in *Microscripts* (2010, 2012), with translations and an introduction by Susan Bernofsky and illustrations by Maira Kalman, in collaboration with publisher Christine Burgin and New Directions, and including an essay by Walter Benjamin. Conceptually, these two books form the literary and visual companions to this catalogue and are the result of years of dedication of everyone listed above (and many others), without whom we would know little of these important works.

The Sea said
"Come" to the Brook —
The Brook said
"Let me grow" —
The Sea said
"Then you will
be a Sea" —
"I want a Brook —
Come now"!
The Sea said
"Go" to the Sea.
The Sea said
"I am he
You cherished" —
"Learned Waters —
Wisdom is stale
to Me."

PL. 30
Emily Dickinson, *The Sea said / Not who toils | for Freedom* (recto), c. 1872

Sea
Sou
Sea
mont G
me non
Sea
to the
Sea
he
Gm
Cherished

in the wave-slant of her hand in *The Sea Said* [PL. 30]. But towards the end of her life there was only the pencil, in conversation with the landscape of her chosen paper's unique shape—though some of the later poems are also copied over into letters to friends. (For all intents and purposes, she never published in her own lifetime and so she did not know her texts as typographic objects). A related trajectory can be found in Walser's career, but in his case, at first glance, the pencil draft would seem to bear little relationship to the final published words. Now we know that in fact, his markings are an archaic *fraktur*-related script autographed into a personal, shorthand-like compression of the letters. Regarding the microscripts, some of which were published in Walser's own lifetime, Susan Bernofsky, who has translated a number of the unpublished ones into English, conjectures that Walser must have made a penned copy for the printers—a version in normal sized, readable, smudge-less script—soon after the pencil draft, as it is unlikely that even he himself would have been able to decode the almost secret text any long time after setting it to paper.

There are distinct parallels between the dyadic relationship of drawing and painting and how, at a time when people wrote mostly by hand, the penciled draft was followed by the "fair-copy" in pen. Just as drawing can be followed by layers of paint that hope to "correct" and fix an image, so the pencil draft is followed by the copy in pen, the permanent record for the typesetter to propagate the text. In many cases, however, these authors never created the "painting;" they never gave us a definitive final text, a definitive manuscript, and as a result, their objects propose the possibility of a temporary language, something closer to the spoken word, a performance more than a score. On Dickinson's part, she subverts the whole notion of finality with her marvelous habit of providing alternate words within a single line of her work, a line that then could be read in two equally vibrant ways. With Walser, it is the romance of the unread book or the unpublished manuscript: you can only recognize that there are words there, but not what the words themselves are. One can bathe in the shape, proportion and tonality of the blocks of marks and their gaps, or ponder their relationship to the visual graphic landscape of the leftover printed marks inhabiting the repurposed paper on which he thriftily wrote.

In a further metaphoric connection to drawing, the pencil plays a key role in the biographies of both writers, forming one of a number of affinities in their histories. The envelope and other surviving fragment works by Dickinson were mostly created after 1872, more or less a decade after she ceased to methodically make fair-copies in pen (which she would subsequently collate and "stab-bound" together, using needle and thread, into what are known as the "fascicles"). These fragments were only found in Dickinson's home after her death (they may have been in a locked box inside a closet). No one had known of their existence while she was alive, though she copied some of the poems into penned letters to her friends. And while we know little of her motivation for writing on these fragments, we do know why she first stopped using a pen to make fair-copies: her doctor directed her to, in order not to exacerbate her vision problems (perhaps related to her "wandering eye"). Apparently he deemed that pen work required such close focus as to be detrimental to her eyesight. Other than some letters, all her late work is in pencil on paper fragments. Cataloged in the archives devoted to her reclusive life is one of her short pencils, around which she pinned a letter she sent to her great friend Samuel Bowles—a little piece of mail art and an ode to this object of changeable thought which opens: "If it had no pencil, | Would it try mine – ".

In the late 1920s, Walser voluntarily committed himself to an asylum in Waldau, where he created a few of the last microscripts while recuperating. But the surviving microscripts mostly predate his withdrawal from the world; evidence suggests this practice began more than a decade before and was a regular procedure in his attempts to express himself. In one, *Pencil Sketch*, Walser alludes to his nervous condition and the ameliorating effect of writing in pencil, albeit in miniature, what he called his "pencil method" [PL. 31]. It seems certain that he ceased writing altogether after he was involuntarily committed to a different asylum, where, perhaps apocryphally, he said, "I am here to be mad not to write." While Walser was diagnosed as schizophrenic, today he might be deemed bi-polar. Assuming the possibility of his being a depressive, Walser's use of the pencil to save himself from creative block is both affecting and instructive. Referring to his "pencil method," he said: "I felt it would make me healthy…let me work more dreamily, peacefully, cozily,

PL. 31
Robert Walser, *Microscript 39* (recto), presumably November–December 1926

contemplatively…I believed that the process I've just described would blossom into a peculiar form of happiness.…" For Walser, it was the notion of the finality of language that inhibited thought. Pencil's inherent impermanence and correctable nature seems to have freed his creativity and gave him hope for his ability to communicate to others and himself.

Imagining the forms and vistas of lost microscripts—let alone the texts of rumored whole novels—one cannot but feel the thrill of fear at Walser's difficulty in keeping the pencil sharp enough, long enough, to record his meandering thoughts, mostly without break, pause, mistake, or rethinking. Though there are some crossing-outs and corrections in his microscripts, many of the published versions show little difference from the first drafts. Walter Benjamin famously claimed that Walser wrote perfect drafts, albeit without knowing of the microscripts' even more uncanny, unworldly perfection. A similar empathy appears when one learns that Dickinson communicated almost exclusively in letters, sending them even to her sister in her own house or her brother next door. Many of her poems were missives for an audience, a reader, of one, a personal language.

Dickinson's pencil-on-paper objects preserve—almost like a photograph—the moment of her thought. The line breaks, inflected by the edges and shapes of the paper, evoke the interactive way she wrote in response not only to her own words but also to their appearance on the paper. (These line breaks, generated in collaboration with the shape of the paper, can only be described as brilliant; see, for example, *One note from | One Bird* [PL. 32].) Her double words, written in pencil, one over the other and still erasable—not crossed out as in ink corrections—offer a metaphor about time and returning afresh to thought. As the poet and scholar Susan Howe described Dickinson's late work to me: "There are no final intentions."

In contrast, Walser's microscripts create a picture or image of the abstraction of language, of how writing is not just speech or thought but also marks made by the body, and translating those marks is an imaginative act, even to the point of the marks building up, becoming so dense that they verge on abstract form. For a writer who is lauded for his ability to evoke such a rich world from prosaic

One note from
One Bird
Is better than
a million words
a scabbard
has- holds
but one
sword

PL. 32
Emily Dickinson, *One note from | One Bird* (recto), c. 1880

PL. 33
Robert Walser, *Microscript 200* (recto), presumably autumn 1928

PL. 33B
Robert Walser, *Microscript 200* (verso), presumably autumn 1928

PL. 34
Robert Walser, *Microscript 72* (recto), September 1927

observation—of walking the countryside for example—it is odd that Walser found it necessary to turn his words into blocks of such dense opacity. An amiable way to explain this would be to point out the repeated appearance of newspaper-like columns of text, and that a number of the microscripts were indeed published in column form in the *feuilletons*. There are wonderful aesthetic relationships between the form of his text blocks and the image or images on the verso or recto of the paper; the connections between this visual play and the contents of the text should not be taken literally, but they are there nonetheless. For example, in *Swine*, an essay of sorts on the universality of same-sex erotic desire, the text pushes all the way to the edge of the paper, as if to ward off what might sneak in otherwise [PLS. 33, 33B]. The words are painfully hemmed in, while on the other side a black square ominously invades the frame. Or take *Autumn II*, which opens with words about "Little clouds": the hole in the paper is like a cloud, and the wisp of a poem in the corner opens with his invented compound word "Light-footed" [PL. 34].

These visual, textual, specific and abstract languages that Dickinson and Walser invented are not lost idioms. They are written languages that are just now becoming argots and spoken dialects evolving on the borders of art, music, performance and poetry: From Jen Berven's artist book edition *The Dickinson Composites* with Granary Press, to Susan Howe's *Frolic Architecture* [PL. 35], a collaboration with photographer James Welling, published by Grenfell Press and New Directions, and which is inspired by her research into Dickinson's late fragment works, to gallerist Donald Young's two-year-long cycle of exhibitions with multiple artists, *In the Spirit of Robert Walser*. In a series of testaments to the two authors' inventions, these new opuses are generating not only a set of new images but also sound and speech, such as poet Christopher Middleton's readings of Walser, or Howe's ongoing collaboration with the musician David Grubbs, or her performance lecture on the visual legacy of "writing" by Dickinson and Jonathan Edwards and William Carlos Williams: *Spontaneous Particulars of Sound*.

I myself was invited to contribute to Young's project (which Christine Burgin and New Directions co-published with Shirley Young as the book *A Little Ramble: In the Spirit of Robert Walser*). In one

**Glorious—what do we
surprisingly Beautiful—and
made manifest and the**
over the surface would ͏͏
erase the letter͏͏ ·

PL. 36
Robert Walser, *Kleine Dichtungen (Small Compositions)*

THE FAREWELL

95

PL. 37
Josiah McElheny, Detail from *A Painter's Life*, 2012

work, inspired by the empty abstract frames that Walser's brother, the artist Karl Walser, drew in soft pencil line for Robert's book covers [PL. 36], I in turn drew in pencil a set of imaginary frames for imaginary paintings that Walser described in his story "A Painter's Life" (1916) [PL. 37]. I saw this as "an iteration on an iteration" and an example of how imaginative narrative can generate a visual abstraction. Robert's story uses titles from real paintings by Karl, and the decorative edges by Karl became, in my prints, an almost Constructivist form: a simple act of drawing a graphite rectangle that is intended to stand in for the memory, with all its wobble and inconsistency, of these imaginary paintings.

Maybe the key to understanding the consequential nature of Dickinson's and Walser's "art-objects"—in which ephemera become a newfound ground—is to reconsider their language as the expression of the body and of the hand as the tool. It used to be common to write in pencil, but no more. We still think of drawing as being done with a pencil—or maybe charcoal, the Ur-instrument of mark making. Writing, though, is no longer typically shaped or drawn by the hand; instead it is a collage of typographic, uniform marks. In a day when perhaps most people write on a screen, my friend, the artist and poet Gregg Bordowitz says, "I write with pencil because I like the sound of it on paper."

PL. 38
Emily Dickinson, *Clogged | only with | Music, like* (recto), c. 1885

PL. 39
Robert Walser, *Microscript 407* (recto), November–December 1927

PL. 39B
Robert Walser, *Microscript 407* (verso), November–December 1927

PL. 40
Emily Dickinson, *Soul, take thy risk* (recto), c. 1867

PL. 40B
Emily Dickinson, *Soul, take thy risk* (verso), c. 1867

How firm Eternity
must look
to crumbling
men like +me ;thee
the only Adamant
Estate
In all Identity –

+ How mighty, to the
insecure + momentous –
thy Physiognomy,
to whom not any
Face +cohere –
+ present – propound

Unless +concealed
in thee + intrenched
 Applied to thee
 inlaid in thee

PL. 41
Emily Dickinson, *How firm Eternity | must look* (recto), c. 1876

heute verreist

Lisa

PL. 42
Robert Walser, *Microscript 364* (recto), September 1925

PL. 42B
Robert Walser, *Microscript 364* (verso), September 1925

PL. 43
Robert Walser, *Microscript 337* (recto), May–June 1926

PL. 43B
Robert Walser, *Microscript 337* (verso), May–June 1926

PL. 44
Robert Walser, *Microscript 116* (recto), December 1928

PL. 44B
Robert Walser, *Microscript 116* (verso), December 1928

PL. 45
Emily Dickinson, Which = has the | wisest men | Undone = / There are those | who are shallow (recto), c. 1880

These are those
who are shallow
intentionally
and only
profound
by
accident —

PL. 45B
Emily Dickinson, Which = has the | wisest men | Undone = / There are those | who are shallow (verso), c. 1880

PL. 46
Emily Dickinson, *Nothing is so | old as a | dilapidated* (recto), c. 1880

PL. 47
Emily Dickinson, *There is no Frigate | like a Book* (recto), c. 1873

PL. 48
Emily Dickinson, *Was never | Frigate like* (recto), c. 1873

In this short Life
that only lasts an hour
merely
How much - how
little - is
within our
power

PL. 49
Emily Dickinson, *In this short Life* (recto), c. 1873

PL. 50
Emily Dickinson, *Not to send | errands by John* (recto), c. 1880

PL. 51
Emily Dickinson, *Society for me | my misery / Or Fame erect | her siteless Citadel –* (recto), c. 1881

The vastest Earthly Day
Is shrunken small
By one Departing
Face
Behind
a Pall –

Is Chastened
small
By one heroic
Face

PL. 52
Emily Dickinson, *The vastest Earthly Day* (recto), c. 1874

Our little
secrets
slink
away –
Beside
God's shall
not will
tell –
He kept
his word
a trillion
years might
are as well –
not
But for the
niggardly
delight
to make
each other
stare

Is there no
smut beneath
the sun
with the
chat may
compare –

PL. 53
Emily Dickinson, *Our little | secrets | slink | away* – (recto), c. 1874

PL. 54
Robert Walser, *Microscript 408* (recto), November–December 1927

PL. 54B
Robert Walser, *Microscript 408* (verso), November–December 1927

PL. 55
Emily Dickinson, *To be forgot | by thee* (recto), c. 1883

PL. 55B
Emily Dickinson, *To be forgot | by thee* (verso), c. 1883

PL. 56
Robert Walser, *Microscript 389* (recto), December 1928–January 1929

PL. 56B
Robert Walser, *Microscript 389* (verso), December 1928–January 1929

All men for Honor
hardest work
But are not known
to earn -
Paid after they have
ceased
ceased to work
In Infamy or Earn -

PL. 57
Emily Dickinson, *All men for Honor | hardest work* (recto), c. 1871

PL. 58
Emily Dickinson, *We | talked with | each other* (recto), c. 1879

as spoke -
were + too
osised with
eends Races
Hoofs of
ock -
in front
+ sentenced

decision

of Reprieve
opened
as -

We talked with
each other about
each other
though neither of
us spoke -
We were listening
to the seconds
Races
and the Hoofs of
the Clock -
Pausing in front
of our palsied
faces
Time compassion
took -
Arks of Reprieve
he offered to us -

PL. 59
Emily Dickinson, *We talked with | each other about | each other* (recto), c. 1879

515 Pausing against our
palsied Faces
Time's decision shook.

PL. 60
Emily Dickinson, *Pausing against our | palsied Faces* (recto), c. 1879

PL. 61
Robert Walser, *Microscript 54* (recto), 1930–1933

PL. 61B
Robert Walser, *Microscript 54* (verso), 1930–1933

With Pinions of
Disdain
The Soul can
farther fly
than any feather
specified
ratified
Certified
in — by —
Ornithology —
It wafts this
sordid Flesh
Beyond it's
Dull — slow control

529a

and daring its
electric
× gale - spell
the Body
is - a soul -
× staff -
might -
act -

span

instructing by
the same - Itself
How little work
it be - what little
a et it be
to pelt ops
filaments like this

PL. 62B
Emily Dickinson, *With Pinions of | Disdain* (verso), c. 1877

The
Mushroom
is the Elf
of Plants –
At Evening,
it is not –
At morning – in a Truffled
Hut
It stop opon a spot
As if it Tarried always
And yet it's whole career
Is shorter than a
snake's delay
And fleeter
than a
+
Tare –

PL. 63
Emily Dickinson, *The | Mushroom | is the Elf | of Plants* – (recto), c. 1874

PL. 63B
Emily Dickinson, *The | Mushroom | is the Elf | of Plants* – (verso), c. 1874

A WORD ON SOURCES

The Dickinson captions reference the following: Ralph W. Franklin, ed., *The Poems of Emily Dickinson*, 3 vols. Cambridge, MA: The Belknap Press of Harvard University Press, 1998; citations are to Franklin #. Thomas H. Johnson, ed., *The Poems of Emily Dickinson*, 3 vols. Cambridge, MA: The Belknap Press of Harvard University Press, 1955; citations are to Johnson #. And Johnson with Theodora Ward, eds., *The Letters of Emily Dickinson*, 3 vols. Cambridge, MA: The Belknap Press of Harvard University Press, 1958; citations are to Johnson L (Letter) # and Johnson PF (Prose Fragment) #.

LIST OF WORKS

PL. 1
Robert Walser in Berlin, c. 1907
Archival exhibition print
3 1/4 x 2 1/4 inches (8.3 x 5.7 cm)
Courtesy Robert Walser-Zentrum,
Christine Burgin and Donald Young Gallery
Photographer unknown

PL. 2
Emily Dickinson, c. 1847
Daguerreotype
6.5 x 3.7 inches (16.5 x 9.5 cm)

PLS. 3, 3B
Robert Walser
Microscript 131, April–May 1926
Recto: one poem, one prose text;
both published
Pencil on envelope from the Ernst Rowohlt
publishing house, Berlin
6 11/16 x 5 1/16 inches (16.9 x 12.8 cm)

PL. 4
Emily Dickinson
Without a smile – | Without a Throe, c. 1874
Amherst # 531; Franklin # 1340;
Johnson P # 1330
Pencil on envelope
4 1/2 x 6 7/10 inches (11.5 x 17 cm)

PL. 5
Emily Dickinson
As there are | Apartments in our, c. 1880
Amherst # 842; Johnson PF # 21
Pencil on envelope
4 7/10 x 3 1/10 inches (12 x 8 cm)

PLS. 6, 6B
Emily Dickinson
*Glass was | the Street – / It came his |
turn to beg –*, c. 1880
Amherst #s 193/194; Franklin #s 1518/1519;
Johnson P #s 1498/1500
Pencil on envelope
(writing on recto and verso)
5 1/2 x 7 9/10 inches (14 x 20 cm)

PL. 7
Robert Walser
Microscript 107, September–November 1928
Recto: one prose text, three poems;
all unpublished
Pencil on *Berliner Tageblatt* stationery
4 5/16 x 2 3/4 inches (10.9 x 6.9 cm)

PL. 8
Robert Walser
Microscript 434, January–March 1928
Recto: one published prose text
Pencil on strip of magazine
5 1/16 x 2 13/16 inches (12.8 x 7.1 cm)

PL. 9
Emily Dickinson
Alone and in a Circumstance, c. 1870
Amherst # 129; Franklin # 1174;
Johnson P # 1167
Pencil, stamp, and magazine clipping on
notepaper (writing on recto and verso)
4 5/8 x 7 inches (11.7 x 17.8 cm)

PL. 10
Emily Dickinson
*Such are the inlets of | the mind – /
He is an Ardent Jockey*, c. 1877
Amherst # 361; Franklin # 1431;
Johnson P # 1421
Pencil on magazine page
(writing on recto and verso)
4 7/8 x 2 1/8 inches (12.4 x 5.4 cm)

PL. 11
Emily Dickinson
Of our deepest delights, after 1873
Amherst # 868; Johnson PF # 96
Pencil on concert program
4 3/4 x 2 1/2 inches (12.1 x 6.4 cm)

PL. 12
Emily Dickinson
If it had no pencil, c. 1861
Amherst # 695; Franklin # 184;
Johnson P # 921
Pencil on paper, pencil stub, and two pins
4 1/10 x 6 7/10 inches (10.5 x 17 cm)

PL. 13
Emily Dickinson
With the sincere spite of a Woman, c. 1880
Amherst # 886; Johnson PF # 124
Pen on paper
3 9/10 x 2 1/5 inches (10 x 5.5 cm)

PL. 14
Emily Dickinson
*Excuse | Emily and | her Atoms /
A Mir | acle for all*, c. 1882
Amherst # 636; Franklin # 1594;
Johnson L # 774
Pencil on envelope
7 1/10 x 9 4/5 inches (18 x 24.9 cm)

PL. 15
Robert Walser
Microscript 419, presumably winter
1927-1928
Verso: one unpublished prose text
Pencil on envelope
5 3/4 x 3 9/16 inches (14.6 x 9 cm)

PL. 16
Robert Walser
Microscript 350, October–December 1928
Recto: one unpublished prose text; two
poems, one published; multiple garbled
poem lines
Pencil on *Berliner Tageblatt* honorarium
receipt
4 1/2 x 2 15/16 inches (11.4 x 7.4 cm)

PL. 17
Robert Walser
Microscript 340, presumably
August–September 1925
Recto: one unpublished poem
Pencil on paper
2 7/8 x 1 1/2 inches (7.2 x 3.8 cm)

PL. 18
Emily Dickinson
The way | Hope builds his | House, c. 1879
Amherst # 450; Franklin # 1512;
Johnson P # 1481
Pencil on envelope
5 3/8 x 5 3/4 inches (13.6 x 14.6 cm)

PL. 19
Emily Dickinson
In vain | to punish | honey, c. 1873
Amherst # 207; Franklin # 1602;
Johnson P # 1562
Pencil on wrapping paper
4 3/10 x 1 inches (11 x 2.5 cm)

PL. 20
Robert Walser
Microscript 215, October–November 1928
Recto: two prose texts, two poems;
all unpublished
Pencil on paper
3 3/4 x 4 1/16 inches (9.5 x 10.3 cm)

PLS. 21, 21B
Robert Walser
Microscript 23, presumably summer 1927
Recto: one published prose text
Pencil on halved calendar page dated
August 15–21, 1926
6 13/16 x 3 1/8 inches (17.3 x 7.9 cm)

PLS. 22, 22B
Emily Dickinson
Necessitates | Celerity, c. 1880
Amherst # 540; Johnson PF # 92
Pencil on chocolate wrapper
2 3/4 x 4 3/4 inches (7 x 12 cm)

PLS. 23, 23B
Emily Dickinson
Two things | I have lost | with Child | hood –,
c. 1870–1886
Amherst # 878; Johnson PF # 117
Pencil on advertisement page
(writing on recto and verso)
13 x 2 1/2 inches (33 x 6.3 cm)

PL. 24
Emily Dickinson
Summer laid | her simple Hat, c. 1876
Amherst # 364; Franklin # 1411;
Johnson P # 1363
Pencil on envelope
7 1/10 x 4 1/2 inches (18 x 11.5 cm)

PL. 25
Emily Dickinson
If wrecked | opon the | Bay of | thought, c. 1879
Amherst # 246; Franklin # 1503;
Johnson P # 1469
Pencil on stationery
2 1/2 x 3 7/8 inches (6.4 x 9 cm)

PL. 26
Emily Dickinson
If wrecked opon | the Shoal of thought, c. 1879
Amherst # 247; Franklin # 1503;
Johnson P # 1469
Pencil on paper (writing on recto and verso)
4 3/4 x 2 5/8 inches (12. x 6.7 cm)

PL. 27
Robert Walser
Microscript 327, presumably spring 1928
Recto: one published prose text,
one unpublished poem
Pencil on wrapping paper
9 5/16 x 2 7/8 inches (23.4 x 7.2 cm)

PL. 28
Emily Dickinson
The Lassitudes | of Contemplation, c. 1882
Amherst # 403; Franklin # 1613;
Johnson P # 1592
Pencil on paper
21 x 4/5 inches (53 x 2 cm)

PLS. 29, 29B
Emily Dickinson
'Twas later when | the summer went, c. 1873
Amherst # 499; Franklin # 1312;
Johnson P # 1276
Pencil on envelope
4 7/10 x 5 7/10 inches (12 x 14.5 cm)

PL. 30
Emily Dickinson
The Sea said | Not who toils | for Freedom,
c. 1872
Pen on stationery
(writing on recto and verso)
Amherst #s 431/432; Franklin #s 1275/1274;
Johnson P #s 1210/1219
5 x 8 inches (12.7 x 20.3 cm)
Not in exhibition

PL. 31
Robert Walser
Microscript 39, presumably
November–December 1926
Recto: two prose texts, one published
Pencil on halved calendar page
6 4/5 x 3 inches (17.3 x 7.75 cm)
Not in exhibition

PL. 32
Emily Dickinson
One note from | One Bird, c. 1880
Amherst # 320; Johnson PF # 97
Pencil on envelope
3 3/10 x 2 1/5 inches (8.5 x 5.5 cm)

PLS. 33, 33B
Robert Walser
Microscript 200, presumably autumn 1928
Recto: one unpublished prose text
Pencil on magazine page
3 3/16 x 2 1/2 inches (8 x 6.3 cm)

PL. 34
Robert Walser
Microscript 72, September 1927
Recto: one unpublished prose text;
one published poem
Pencil on postal wrapper
4 1/2 x 4 inches (11.4 x 10.1 cm)

PL. 35
Susan Howe
From *Frolic Architecture*, 2010
Letterpress print on Somerset paper
11 x 8 1/2 inches (27.9 x 21.6 cm)
Courtesy The Grenfell Press
Not in exhibition

PL. 36
Robert Walser
Kleine Dichtungen (Small Compositions)
(with cover by Karl Walser)
Published 1914 by Kurt Wolff
Courtesy Robert Walser-Zentrum,
Christine Burgin and Donald Young Gallery
©Keystone/Robert Walser Foundation Bern
Photographer: Dominique Uldry
Not in exhibition

PL. 37
Josiah McElheny
Detail from *A Painter's Life*, 2012
Eight letterpress prints on vintage
handmade Umbria paper
Edition of twelve and eight artist's proofs
Paper size: 12 x 9 1/4 inches
(30.5 x 23.5 cm), each
Set in Granjon and printed letterpress
at The Grenfell Press
Published by Donald Young Gallery
Not in exhibition

PL. 38
Emily Dickinson
Clogged | only with | Music, like, c. 1885
Amherst # 821; Johnson L # 976
Pencil on two pieces of envelope
5 1/10 x 4 1/10 inches (13 x 10.5 cm);
2 3/5 x 1 2/5 inches (6.5 x 3.5 cm)

PLS. 39, 39B
Robert Walser
Microscript 407, November–December 1927
Recto: one published prose text; eight poems,
two published; Verso: one unpublished poem
Pencil on *Berliner Tageblatt* honorarium receipt
6 6/16 x 4 15/16 inches (16.1 x 12.5 cm)

PLS. 40, 40B
Emily Dickinson
Soul, take thy risk, c. 1867
Amherst # 357; Franklin # 1136;
Johnson P # 1151
Pencil on stationery
(writing on recto, drawing on verso)
3 7/8 x 1 7/8 inches (9.8 x 4.8 cm)

PL. 41
Emily Dickinson
How firm Eternity | must look, c. 1876
Amherst # 219; Franklin # 1397;
Johnson P # 1499
Pencil on paper
8 x 5 3/4 inches (20.3 x 14.6 cm)

PLS. 42, 42B
Robert Walser
Microscript 364, September 1925
Recto: one unpublished prose text;
thirteen poems, four published;
Verso: one unpublished prose text;
fourteen poems, ten published
Pencil on telegram from Lisa Walser
dated September 7, 1925
9 1/16 x 7 2/16 inches (23 x 18 cm)

PLS. 43, 43B
Robert Walser
Microscript 337, May–June 1926
Recto: one published prose text
Pencil on sheet from a tear-off calendar
dated Sunday, May 16, 1926
5 3/16 x 2 11/16 inches (13.1 x 6.8 cm)

PLS. 44, 44B
Robert Walser
Microscript 116, December 1928
Recto: five poems, one prose text;
Verso: one prose text; all unpublished
Pencil on stationery card
4 3/8 x 2 3/4 inches (11.1 x 6.9 cm)

PLS. 45, 45B
Emily Dickinson
W̶h̶i̶c̶h̶ ̶=̶ ̶h̶a̶s̶ ̶t̶h̶e̶ | w̶i̶s̶e̶s̶t̶ ̶m̶e̶n̶ | U̶n̶d̶o̶n̶e̶ = /
There are those | *who are shallow*, c. 1880
Amherst # 539; Johnson PF #s 122/113
Pencil on envelope
(writing on recto and verso)
3 1/10 x 3 inches (8 x 7.5 cm)

PL. 46
Emily Dickinson
Nothing is so | *old as a* | *dilapidated*, c. 1880
Amherst # 866; Johnson PF # 94
Pencil on notepaper
2 4/5 x 1 9/10 inches (7.2 x 4.8 cm)

PL. 47
Emily Dickinson
There is no Frigate | *like a Book*, c. 1873
Amherst # 462; Franklin # 1286;
Johnson P # 1263
Pencil on two sheets of paper
3 9/10 x 2 3/5 inches (10 x 6.5 cm);
5 1/2 x 1 4/5 inches (14 x 4.5 cm)

PL. 48
Emily Dickinson
Was never | *Frigate like*, c. 1873
Amherst # 463; Franklin # 1286;
Johnson P # 1263
Pencil on envelope
3 7/10 x 2 3/5 inches (9.5 x 6.5 cm)

PL. 49
Emily Dickinson
In this short Life, c. 1873
Amherst # 252; Franklin # 1292;
Johnson P # 1287
Pencil on envelope
4 7/10 x 2 1/5 inches (12 x 5.5 cm)

PL. 50
Emily Dickinson
Not to send | *errands by John*, c. 1880
Amherst # 865; Johnson PF # 93
Pencil on envelope
3 3/10 x 2 4/5 inches (8.5 x 7 cm)

PL. 51
Emily Dickinson
Society for me | my misery / Or Fame erect | her siteless Citadel –, c. 1881
Amherst #s 351/352; Franklin #s 1195/1227;
Johnson #s P 1534/1183
Pencil on envelope
9 1/2 x 2 1/3 inches (24 x 5.9 cm)

PL. 52
Emily Dickinson
The vastest Earthly Day, c. 1874
Amherst # 449; Franklin # 1323;
Johnson P # 1328
Pencil on envelope
8 9/10 x 2 1/5 inches (22.6 x 5.5 cm)

PL. 53
Emily Dickinson
Our little | secrets | slink | away –, c. 1874
Amherst # 324; Franklin # 1318;
Johnson P # 1326
Pencil on wrapping paper
4 1/2 x 8 9/10 inches (11.5 x 22.6 cm)

PLS. 54, 54B
Robert Walser
Microscript 408, November–December 1927
Recto: two prose texts, one published
Pencil on postal wrapper
4 1/2 x 4 3/16 inches (11.4 x 10.6 cm)

PLS. 55, 55B
Emily Dickinson
To be forgot | by thee, c. 1883
Amherst # 484; Franklin # 1601;
Johnson P # 1560
Pencil on advertisement page
(writing on recto and verso)
6 1/2 x 6 inches (10.2 x 12.4 cm)

PLS. 56, 56B
Robert Walser
Microscript 389, December 1928–January 1929
Recto: one prose text, two poems;
Verso: one poem; all unpublished
Pencil on business card of Hans Marty Burgdorf, importer of English fabrics
4 9/16 x 2 15/16 inches (11.5 x 7.4 cm)

PL. 57
Emily Dickinson
All men for Honor | hardest work, c. 1871
Amherst # 128; Franklin # 1205;
Johnson P # 1193
Pencil on envelope
1 1/8 x 2 inches (2.9 x 5.1 cm)

PL. 58
Emily Dickinson
We | talked with | each other, c. 1879
Amherst # 514; Franklin # 1506;
Johnson P # 1473
Pencil on envelope
5 1/10 x 7 9/10 inches (13 x 20 cm)

PL. 59
Emily Dickinson
We talked with | each other about | each other,
c. 1879
Amherst # 516; Franklin # 1506;
Johnson P # 1473
Pencil on student account book page
4 1/10 x 6 1/2 inches (10.4 x 16.5 cm)

PL. 60
Emily Dickinson
Pausing against our | palsied Faces, c. 1879
Amherst # 515; Franklin # 1506;
Johnson P # 1473
Pencil on wrapping paper
4 3/4 x 1 inches (12 x 2.5 cm)

PLS. 61, 61B
Robert Walser
Microscript 54, 1930–1933
Recto: one unpublished prose text
Pencil on back of cover of book
5 1/16 x 4 1/16 inches (12.8 x 10.3 cm)

PLS. 62, 62B
Emily Dickinson
With Pinions of | Disdain, c. 1877
Amherst # 529; Franklin # 1448;
Johnson P # 1431
Pencil on wrapping paper
(writing on recto and verso)
3 3/4 x 4 3/4 inches (9.5 x 12.1 cm)

PLS. 63, 63B
Emily Dickinson
The | Mushroom | is the Elf | of Plants –,
c. 1874
Amherst # 416; Franklin # 1350;
Johnson P # 1298
Pencil on envelope
6 1/2 x 6 inches (16.5 x 15.2 cm)

EXHIBITION WORKS NOT PICTURED

Emily Dickinson
When what | they sung for | is undone, c. 1881
Amherst # 108; Franklin # 1545;
Johnson P # 1530
Pencil on envelope
6 9/10 x 5 3/10 inches (17.5 x 13.5 cm)

Emily Dickinson
A Pang is more | Conspicuous in Spring, c. 1881
Amherst # 109; Franklin # 1545;
Johnson P # 1530
Pencil on envelope
7 3/4 x 6 1/8 inches (20 x 17.3 cm)

Emily Dickinson
As old as Woe –, c. 1870
Amherst # 139; Franklin # 1259;
Johnson P # 1168
Pencil on envelope
6 3/10 x 5 1/2 inches (16 x 14 cm)

Emily Dickinson
Had we our | Senses, c. 1873
Amherst #202; Franklin # 1310;
Johnson P # 1284
Pencil on envelope
4 7/10 x 5 1/2 inches (12 x 14 cm)

Emily Dickinson
Long Years | apart – can, c. 1876
Amherst # 277; Franklin # 1405;
Johnson P # 1383
Pencil on envelope
(writing on recto and verso)
5 7/10 x 4 3/10 inches (14.5 x 11 cm)

Emily Dickinson
Look back | on Time, c. 1872
Amherst # 278; Franklin # 1251;
Johnson P # 1478
Pencil on envelope
6 1/2 x 5 3/10 inches (16.5 x 13.5 cm)

Emily Dickinson
Myself compu- | ted were they | Pearls / Oh Magnanimity –, c. 1873
Amherst #s 313/314; Franklin #s 1208/846;
Johnson P #s 794/1180
Pencil on envelope
5 7/10 x 5 3/10 inches (14.5 x 13.5 cm)

Emily Dickinson
Some Wretched | creature, savior | take, c. 1867
Amherst # 355; Franklin # 1132;
Johnson P # 1111
Pencil on envelope
3 1/10 x 3 1/10 inches (7.9 x 7.9 cm)

Emily Dickinson
The Ditch | is dear to the | Drunken man,
c. 1885
Amherst # 391; Franklin # 1679;
Johnson P # 1645
Pencil on envelope
(writing on recto and verso)
7 9/10 x 5 1/2 inches (20 x 14 cm)

Emily Dickinson
The fairest Home I ever | knew /
Accept my timid happiness –, c. 1877
Amherst #s 394/394a; Franklin # 1443;
Johnson P # 1423, L # 528
Pencil on envelope
(writing on recto and verso)
5 x 1 3/8 inches (12.7 x 3.5 cm)

Emily Dickinson
The Spry Arms | of the Wind, c. 1864
Amherst # 438; Franklin # 802;
Johnson P # 1103
Pencil on envelope
(writing on recto and verso)
6 3/10 x 5 7/10 inches (16 x 14.5 cm)

Robert Walser
Microscript 9, June–July 1932
Recto: seven prose texts;
Verso: three prose texts; all unpublished
Pencil on *Neue Zurcher Zeitung*
stationery card
6 1/16 x 4 2/16 inches (15.3 x 10.4 cm)

Robert Walser
Microscript 12, June–July 1927
Recto: two unpublished prose texts
Pencil on halved calendar page
dated August 15–21, 1926
6 13/16 x 3 1/16 inches (17.3 x 7.7 cm)

Robert Walser
Microscript 47, 1930–1933
Verso: two unpublished prose texts
Pencil on envelope
4 6/8 x 4 3/16 inches (12 x 11.5 cm)

Robert Walser
Microscript 50, 1930–1933
Recto: one unpublished prose text
Pencil on strip of magazine
5 x 1 13/16 inches (12.7 x 4.6 cm)

Robert Walser
Microscript 75, autumn 1928
Recto: two unpublished prose texts
Pencil on *Berliner Tageblatt* honorarium receipt
4 1/2 x 2 7/8 inches (11.3 x 7.3 cm)

Robert Walser
Microscript 85, autumn 1928
Recto: two unpublished prose texts
Pencil on *Berliner Tageblatt* honorarium receipt
4 3/8 x 2 7/8 inches (11.1 x 7.2 cm)

Robert Walser
Microscript 86, autumn 1928
Recto: two unpublished prose texts
Pencil on *Berliner Tageblatt* honorarium receipt
4 1/2 x 2 7/8 inches (11.4 x 7.3 cm)

Robert Walser
Microscript 149, November–December 1925
Recto: one unpublished prose text
Pencil on galley page
6 x 3 1/2 inches (15.2 x 8.9 cm)

Robert Walser
Microscript 153, December 1925
Recto: one prose text, one poem; both published
Pencil on galley page
5 15/16 x 3 3/8 inches (15.1 x 8.6 cm)

Robert Walser
Microscript 190, March–April 1925
Recto: three unpublished prose texts
Pencil on art print paper
8 7/16 x 5 1/16 inches (21.4 x 12.8 cm)

Robert Walser, 1892/93
Archival exhibition print
3 1/2 x 2 1/4 inches (8.9 x 5.7 cm)
Courtesy Robert Walser-Zentrum,
Christine Burgin and Donald Young Gallery
Photographer unknown

Robert Walser in Biel, 1899
Archival exhibition print
5 5/8 x 3 3/4 inches (14.3 x 9.5 cm)
Courtesy Robert Walser-Zentrum,
Christine Burgin and Donald Young Gallery
Photograph by Paul Renfer

Robert Walser, 1909
Archival exhibition print
3 1/8 x 3 1/4 inches (7.9 x 8.3 cm)
Courtesy Robert Walser-Zentrum,
Christine Burgin and Donald Young Gallery
Photographer unknown

Robert Walser on a Walk, January 3, 1937
Archival exhibition print
4 1/8 x 3 1/8 inches (10.5 x 8 cm)
Courtesy Robert Walser-Zentrum,
Christine Burgin and Donald Young Gallery
Photograph by Carl Seelig

Robert Walser on a Walk, July 20, 1941
Archival exhibition print
4 1/2 x 3 3/8 inches (11.4 x 8.5 cm)
Courtesy Robert Walser-Zentrum,
Christine Burgin and Donald Young Gallery
Photograph by Carl Seelig

Robert Walser on Good Friday, 1954
Archival exhibition print
4 5/8 x 3 1/8 inches (11.7 x 7.9 cm)
Courtesy Robert Walser-Zentrum,
Christine Burgin and Donald Young Gallery
Photograph by Carl Seelig

All Dickinson works and images courtesy
The Emily Dickinson Collection, Amherst
College Archives & Special Collections.

All Robert Walser works courtesy of
Robert Walser-Zentrum © Keystone /
Robert Walser-Stiftung Bern.

Images for plates 3/3B, 7, 8, 15, 16, 20,
21/21B, 34, 39/39B, 42/42B, 43/43B,
44/44B, 54/54B, 56/56B, 61/61B:
Courtesy of Christine Burgin.

Images for all other Walser plates:
Courtesy of Robert Walser-Zentrum.

CONTRIBUTOR BIOS

Claire Gilman is Curator at The Drawing Center.

Josiah McElheny is a New York-based sculptor, performance artist, writer, and filmmaker best known for his use of glass with other materials. In 2012 and 2013, his work was the subject of two major survey exhibitions, *Some Pictures of the Infinite* at the Institute for Contemporary Art in Boston, Massachusetts and *Towards a Light Club* at the Wexner Center for the Arts, Columbus, Ohio. He has written for such publications as *Artforum* and *Cabinet*, and is a contributing editor to *Bomb Magazine*. Book projects include *The Light Club*, published by the University of Chicago Press in 2010 and *Interiors*, a reader co-edited by Johanna Burton and Lynne Cook, published by CCS Bard and Sternberg Press in 2012, as well as participation in *A Little Ramble: In the Spirit of Robert Walser* published in 2012 by New Directions and Christine Burgin. In 2006 he was the recipient of a MacArthur Foundation Fellowship.

BOARD OF DIRECTORS

Co-Chairs
Frances Beatty Adler
Eric Rudin
Jane Dresner Sadaka

Treasurer
Stacey Goergen

Secretary
Dita Amory

Brad Cloepfil
Anita F. Contini
Steven Holl
Rhiannon Kubicka
David Lang
Merrill Mahan
Iris Z. Marden
Nancy Poses
Pat Steir
Barbara Toll
Isabel Stainow Wilcox
Candace Worth

Emeritus
Melva Bucksbaum
Frances Dittmer
Bruce W. Ferguson
Michael Lynne
George Negroponte
Elizabeth Rohatyn
Jeanne C. Thayer

Executive Director
Brett Littman

ACKNOWLEDGMENTS

Dickinson/Walser: Pencil Sketches is made possible by the Swiss Arts Council Pro Helvetia, Consulate General of Switzerland in New York, and New York Council for the Humanities.

swiss arts council
prohelvetia

Schweizerische Eidgenossenschaft
Confédération suisse
Confederazione Svizzera
Confederaziun svizra

Consulate General of Switzerland in New York

New York Council for the Humanities

EDWARD HALLAM TUCK PUBLICATION PROGRAM

This is number 109 of the *Drawing Papers*, a series of publications documenting The Drawing Center's exhibitions and public programs and providing a forum for the study of drawing.

Jonathan T.D. Neil *Executive Editor*
Joanna Ahlberg *Managing Editor*
Designed by Peter J. Ahlberg / AHL&CO

This book is set in Adobe Garamond Pro and Berthold Akzidenz Grotesk. It was printed by Bookmobile in Minneapolis, Minnesota.

ISBN 978-0-942324-79-2
© 2013 THE DRAWING CENTER

THE DRAWING PAPERS SERIES ALSO INCLUDES

Drawing Papers 108 *Drawing Time, Reading Time*
Drawing Papers 107 *Alexis Rockman: Drawings from* Life of Pi
Drawing Papers 106 *Susan Hefuna and Luca Veggetti: NOTATIONOTATIONS*
Drawing Papers 105 *Ken Price: Slow and Steady Wins the Race, Works on Paper 1962–2010*
Drawing Papers 104 *Giosetta Fioroni: L'Argento*
Drawing Papers 103 *Igancio Uriarte: Line of Work*
Drawing Papers 102 *Alexandre Singh: The Pledge*
Drawing Papers 101 *José Antonio Suárez Londoño: The Yearbooks*
Drawing Papers 100 *Guillermo Kuitca: Diarios*
Drawing Papers 99 *Sean Scully: Change and Horizontals*
Drawing Papers 98 *Drawing and its Double: Selections from the Istituto Nazionale per la Grafica*
Drawing Papers 97 *Dr. Lakra*
Drawing Papers 96 *Drawn from Photography*
Drawing Papers 95 *Day Job*
Drawing Papers 94 *Paul Rudolph: Lower Manhattan Expressway*
Drawing Papers 93 *Claudia Wieser: Poems of the Right Angle*
Drawing Papers 92 *Gerhard Richter: "Lines which do not exist"*
Drawing Papers 91 *Dorothea Tanning: Early Designs for the Stage*
Drawing Papers 90 *Leon Golub: Live & Die Like a Lion?*
Drawing Papers 89 *Selections Spring 2010: Sea Marks*
Drawing Papers 88 *Iannis Xenakis: Composer, Architect, Visionary*
Drawing Papers 87 *Ree Morton: At the Still Point of the Turning World*
Drawing Papers 86 *Unica Zurn: Dark Spring*
Drawing Papers 85 *Sun Xun: Shock of Time*
Drawing Papers 84 *Selections Spring 2009: Apparently Invisible*
Drawing Papers 83 *M/M: Just Like an Ant Walking on the Edge of the Visible*
Drawing Papers 82 *Matt Mullican: A Drawing Translates the Way of Thinking*
Drawing Papers 81 *Greta Magnusson Grossman: Furniture and Lighting*
Drawing Papers 80 *Kathleen Henderson: What if I Could Draw a Bird that Could Change the World?*
Drawing Papers 79 *Rirkrit Tiravanija: Demonstration Drawings*

TO ORDER, AND FOR A COMPLETE CATALOGUE OF PAST EDITIONS,
VISIT DRAWINGCENTER.ORG

THE
DRAWING
CENTER

35 WOOSTER STREET | NEW YORK, NY 10013
T 212 219 2166 | F 212 966 2976 | DRAWINGCENTER.ORG